CONTENTS

TEXTURED INTERPLAY
The Abstract Art of Ellida Schargo von Alten

TEXTURED INTERPLAY
The Abstract Art of
Ellida Schargo von Alten

Eleanor Moseman

Schargo von Alten, Ellida
TEXTURED INTERPLAY
The Abstract Art of Ellida Schargo von Alten / Eleanor Moseman; design by Silvia Minguzzi.
52 p. : col. Ill. ; 20.32 x 20.32 cm.

Published to accompany the exhibition: Textured interplay : the abstract art of Ellida Schargo von Alten,
February 3, 2012 – April 7, 2012 at the Colorado State University Art Museum.
ISBN-13: 978-1-889143-22-4
ISBN-10: 1-889143-22-7

1. Schargo von Alten, Ellida – Exhibitions. 2. Colorado State University. University Art Museum –
Exhibitions. 3. Drawing– Germany – 20th century – Exhibitions. 4. Art, Abstract – Germany – 20th
century – Exhibitions. 5. Art, German – 20th century – Exhibitions. 6. Installations (Art) – Exhibitions.
I. Colorado State University. University Art Museum. II. Moseman, Eleanor. III. Minguzzi, Silvia.
NC15. C65 2013

Cataloging record provided by Colorado State University Libraries.
University Art Museum
Colorado State University
Fort Collins, CO 80523-1778
Tel: 970-491-1989
Artmuseum.colostate.edu

Ellida Schargo von Alten in Worpswede, ca. 1940, Photograph
Courtesy of Till and Hilde Schargorodsky

The dress designer, writer, and pastel artist Ellida Schargo von Alten (b. June 13, 1911, Hannover; d. December 17, 1996, Herzberg) derived evocative moods and subjects from the imagination. Her early writings channel memories of a carefree childhood pursuing summer adventures with her six siblings at Rittergut Posteholz, the von Alten family's rural estate in north-central Germany. Later short stories blend fantastic escapades with profound insights into human nature, offering readers an outlet for making sense of the contradictions of life in a wartorn country. Many of von Alten's narrative quests involve navigating water and her abstract artworks often conjure glistening light on rippling undulations and swirls of waves and eddies. Named after the tall-masted ship *The Ellida* captained by her grandfather Georg Julius von Alten, Ellida recorded her life-long attraction to water and the vessels that ply them, from ponds and lakes, streams and rivers, to rolling seas and vast oceans.

Von Alten began her variegated career working with textiles and immersing herself in art. She completed an apprenticeship as a seamstress in Hannover (1929-1932), a professional trajectory that served her throughout her life. In the late 1920s and early '30s she regularly attended exhibitions of avant-garde artists, including Bauhaus masters Wassily Kandinsky, Lyonel Feininger, and Paul Klee, and may have been introduced to Constructivism.[1] In 1932

von Alten began coursework in fashion design, drawing, and color theory at Hannover's School for Applied Art. There, drastic changes could be felt after January 1933 when Hitler took office and systematic Nazification of German cultural life began. Under the Nazis' new rules students at the school were required to salute Hitler every hour, a practice that was more than von Alten could bear.[2] She quit her studies and opened her own fashion studio at her parents' house.

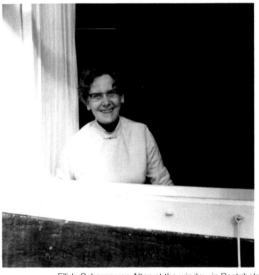

Ellida Schargo von Alten at the window in Posteholz, late 1970s/ early 1980s, Photograph
Courtesy of Jessica G. Davis

While enrolled at the School for Applied Art von Alten met the aspiring writer Erich Schargorodsky (pen-name Görge Spervogel). In 1932 they visited Worspwede; the artist-enclave would become their home in 1936 after they married in 1934.[3] Ellida took her husband's name, but continued to publish under her maiden name and later signed her artworks with the initials EvA. Their son Till was born in 1935, followed by their daughter Göntje in 1937. In an act of civil defiance, the new parents chose to give the children names that did not appear on the Nazis' recommended list.[4] Shortly after Göntje's birth the family moved to the section of Worpswede called "Hinterm Berg" where they spent the first years of the war. Unaware of the Schargorodsky family's Jewish-Ukranian heritage,[5] the Nazis conscripted Erich as a war journalist in 1939 and sent him to the Eastern Front; he died in Russia in 1942. Around 1941 von Alten moved with Till and Göntje to "Haus Seekamp" in the center of Worpswede.

Long before war broke out, von Alten began writing. Encouraged by Erich and fueled by her strong imagination and childhood memories, she wrote short stories that she published in German newspapers starting in 1934. Her novel *Kindersommer* (Children's Summer) was published in 1941 with the popular Berlin publisher Fischer-Verlag. Word of the book spread fast thanks to the preview in the ubiquitous *Frankfurter Zeitung* and a second printing occurred

Ellida Schargo von Alten in Worpswede
ca. 1934/1935, Photograph
Courtesy of Till and Hilde Schargorodsky

only a year later.[6] In Erich's absence, von Alten continued writing short stories to supplement the family's income, but as the strains of war began affecting media outlets, many of her writings remained unpublished. Suddenly finding herself a war widow and single parent of young children, von Alten had to invent a new life to sustain herself and her family. At "Haus Seekamp" in Worpswede she set up a workshop for women's and children's apparel and mending in 1945.[7] She also designed costuming for art festivals and worked with the local children's theater. Abiding interest in avant-garde art accompanied her as she attended art exhibitions, including one in 1948 featuring the German Surrealist Richard Oelze.

After the war von Alten resumed making visual art. Since childhood she was constantly drawing and later applied her rendering talents to dress design.[8] Immersed in the world of patterned cloth, drapery folds, and textured fabrics, von Alten absorbed the appearance and behavior of textiles and the logic of uniting disparate pieces to create imaginative cloth confections. In addition to watery references, the undulations of rumpled fabric and haphazard contrasts of stacked patterned skeins spill over into von Alten's drawings and pastels of the 1950s and 60s. Intricate lace and nubby courduroy, slippery satin and coarse felt: the interplay of material variation informs the shadow-scapes in von Alten's art. Not fully representational, and yet whimsically evocative of the natural world, these abstract images beguile the viewer with the transformative potential of illusionistic texture.

Ellida Schargo von Alten at sea
mid 1930s, Photograph
Courtesy of Till and Hilde Schargorodsky

1 "Biographie" in *Ellida Schargo von Alten: Zeichnungen und Gemälde* (Worpswede: Galerie Cohrs-Zirus, 1994), 5. To date, the
Cohrs-Zirus exhibition catalogue is the only published work on the life and art of von Alten. In addition to this text a modest number
of reviews were written in 1941 about her novel *Kindersommer* and in conjunction with her 1991 exhibition at the Kunstverein
Hameln. A flurry of newspaper reviews followed the 1994 Cohrs-Zirus exhibition. Since that time there have been no publications on
von Alten's work, although Galerie Cohrs-Zirus continues to include her pastels in occasional group exhibitions. Archival research
indicates that von Alten was directly involved in editing and approving the biographical sketch and interpetive text published in the
1994 Cohrs-Zirus catalogue, as well as guiding the selection of works included in the exhibition and reproduced in the catalogue.
2 Personal communication with Till Schargorodsky, son of the artist, July 2012.
3 "Biographie," 5-6.
4 Personal communication with Jessica G. Davis, granddaughter of the artist, April 17, 2011.
5 Personal communication with Jessica G. Davis, April 17, 2011 and Till Schargorodsky, July 2012.
6 "Biographie," 6. See also von Alten archivalia in Barkenhoffstiftung, Worpswede.
7 "Biographie," 6 and personal communication with Till Schargorodsky, July 2012. See also von Alten archivalia in
Barkenhoffstiftung, Worpswede.
8 See archivalia in the collection of Till Schargorodsky, including childhood drawings from the 1920s and textile studies from
her studies at the Kunstgewerbeschule in the early 1930s. Drawings in this archival collection dated to the late 1940s include
landscapes and illustrations for her short stories.

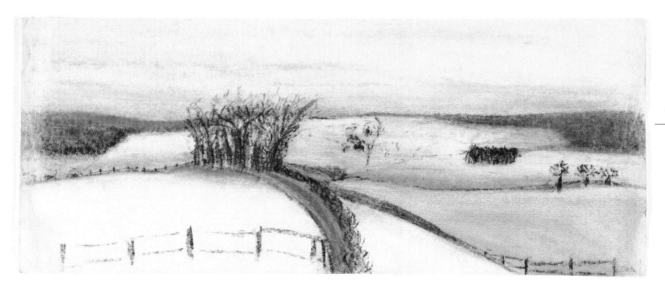

Verso

Landschaft, 1933
Landscape
Pastel on paper
14 x 35 cm (5 ½ x 13 ¾ in), signed on back
and dated 27.II.33
On loan from Jessica G. Davis, Erik V. Davis,
Emily K. Abraham and Marc B. Davis

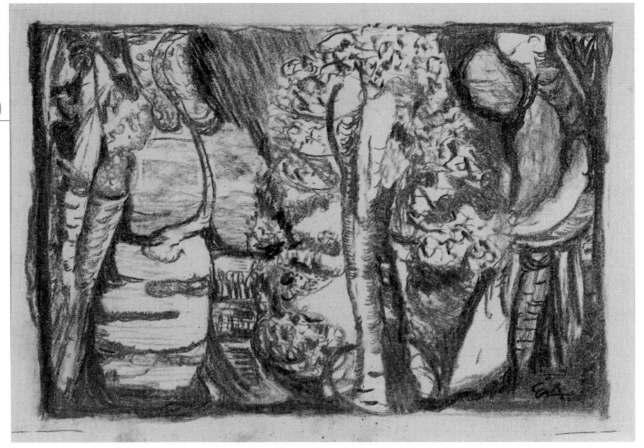

Bäume, ca. 1949
Trees
Charcoal on paper
21 x 30 cm (8 3/8 x 11 ¾ in), signed lower right
On loan from Jessica G. Davis, Erik V. Davis,
Emily K. Abraham and Marc B. Davis

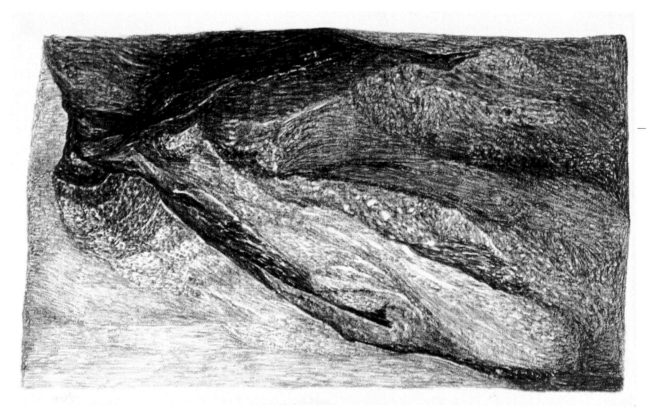

The German word Wogen has multiple meanings:
as a noun it means waves or troubled waters; as a
verb it means surge, wave, rage, or heave.

Wogen, undated
Charcoal and Conté crayon on board
20 x 33 cm (7 7/8 x 13 in), signed lower left
On loan from Jessica G. Davis, Erik V. Davis,
Emily K. Abraham and Marc B. Davis

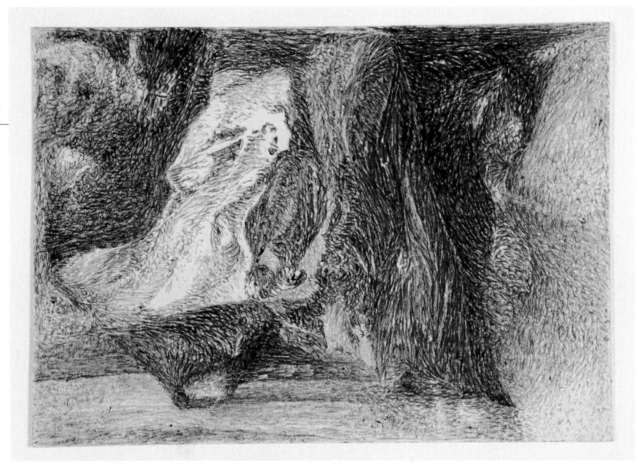

Unterm Baumstamm, undated
Under the Tree Trunk
Pen on paper
10.5 x 15 cm (4 1/8 x 5 7/8 in), unsigned
On loan from Jessica G. Davis, Erik V. Davis,
Emily K. Abraham and Marc B. Davis

While the term "Baumstamm" means tree trunk, reversing the components of the compound noun produces "Stammbaum" which means family tree. In her writing, von Alten often utilized words with playful reversals like this example.

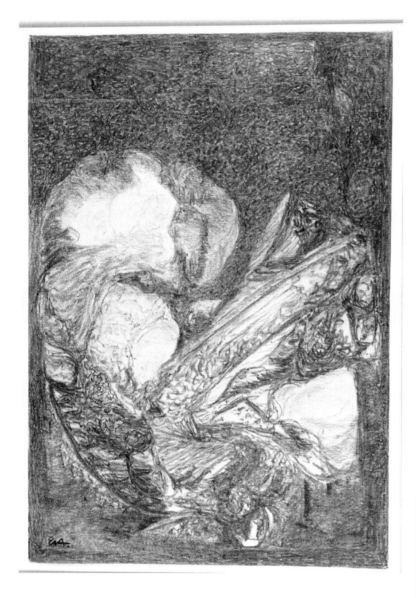

Blumenstilleben, 1949/1951
Flower Still Life
Conté crayon on paper
60 x 42 cm (23 5/8 x 16 ½ in), signed
lower left
On loan from Jessica G. Davis, Erik V.
Davis, Emily K. Abraham and Marc B.
Davis

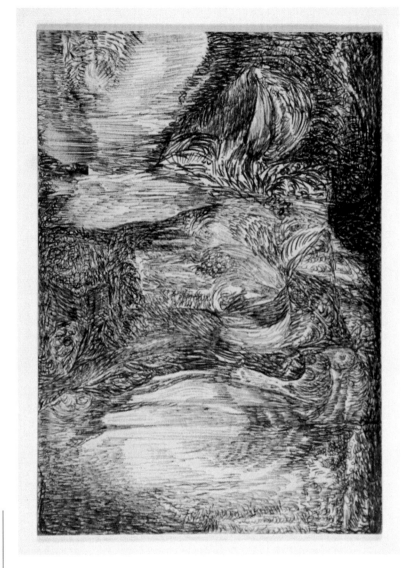

Blumen I, ca. 1955
Flowers I
Pen on board
14.5 x 10.5 cm (5 ¾ x 4 1/8 in), unsigned
On loan from Jessica G. Davis, Erik V. Davis,
Emily K. Abraham and Marc B. Davis

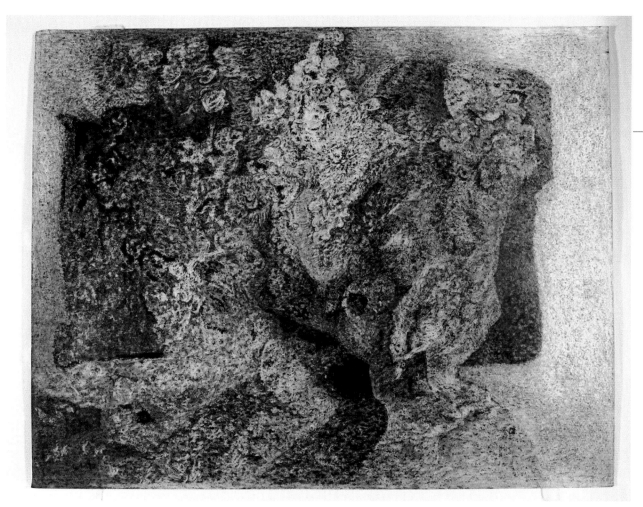

Blumenfrau, 1962
Flower-Woman
Pastel on black paper
65 x 50 cm (25 5/8 x 19 ¾ in), signed lower left
On loan from Jessica G. Davis, Erik V. Davis,
Emily K. Abraham and Marc B. Davis

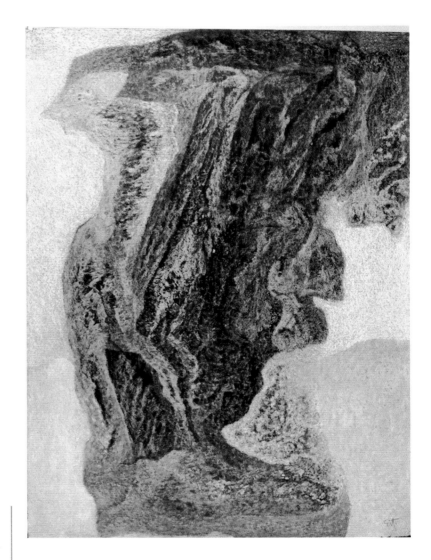

Naturstein, 1967
Natural Stone
Pastel on black paper
63.5 x 49.5 cm (25 x 19 ½ in),
signed lower right
On loan from Jessica G. Davis, Erik V. Davis,
Emily K. Abraham and Marc B. Davis

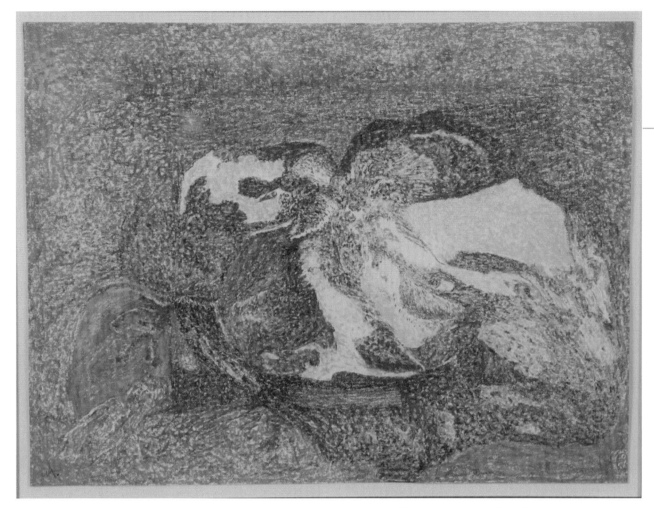

Desertszene, undated
Desert Scene
Pastel on paper
61 x 73.7 cm (24 x 29 in), signed lower left
On loan from Jessica G. Davis

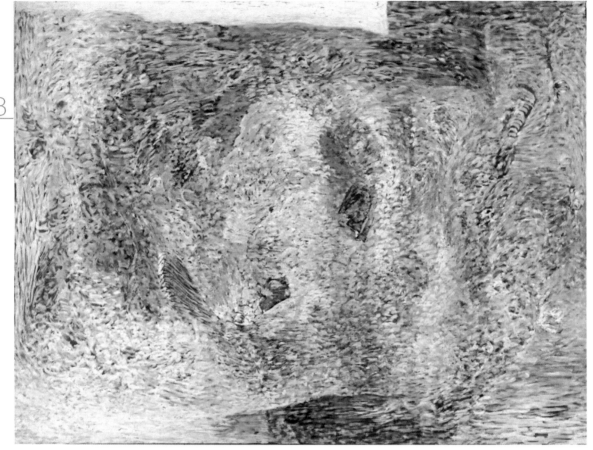

Farbstudie (Pointilismus), ca. 1965
Color Study (Pointillism)
Gouache and pastel on black paper
65 x 50 cm (25 5/8 x 19 ¾ in), unsigned
On loan from Jessica G. Davis, Erik V. Davis,
Emily K. Abraham and Marc B. Davis

Detail

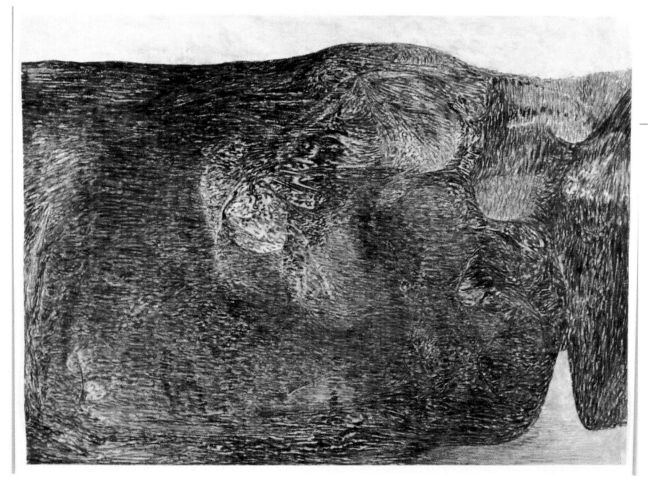

Mauer, 1966
Wall
Pastel and charcoal on paper
45 x 62.5 cm (17 ¾ x 24 5/8 in), unsigned
On loan from Jessica G. Davis, Erik V. Davis,
Emily K. Abraham and Marc B. Davis

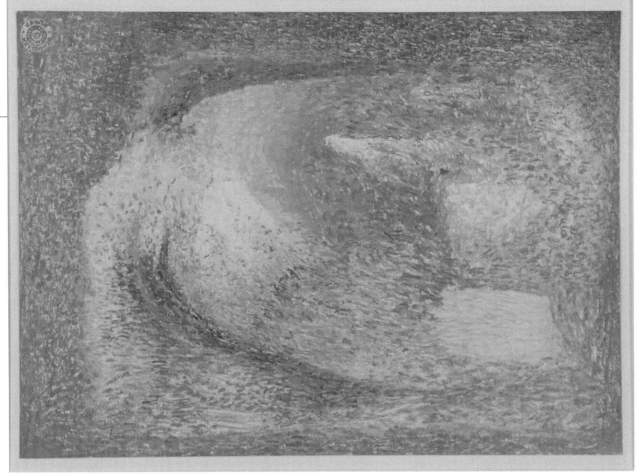

Farbstudie, 1965
Color Study
Oil pastel on paper
45 x 62.5 cm (17 ¾ x 24 5/8 in), unsigned
On loan from Jessica G. Davis, Erik V. Davis,
Emily K. Abraham and Marc B. Davis

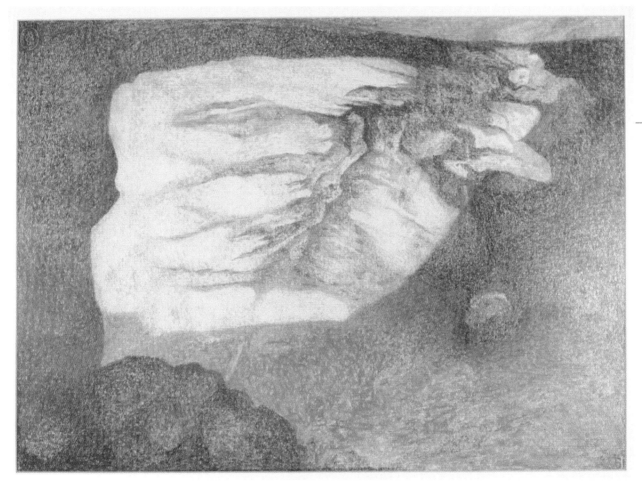

Untitled, undated
Pastel on paper
58.4 x 76.2 cm (23 x 30 in), signed lower right
On loan from Jessica G. Davis

NAVIGATING THE IMAGINATION:
Surrealist Partnership

Ellida Schargo von Alten seated beneath *Naturstein* in Posteholz,
after 1967, Photograph
Courtesy of Till and Hilde Schargorodsky

As a fiction writer Ellida Schargo von Alten explored the inner workings of the mind through fantastical narrative episodes and imaginative descriptions. Her drawings and pastels from the late 1940s on continued this practice of deriving motifs and subject matter from the imagination. Compositions featuring organic forms referencing nature but reconfigured in abstract arrangements became the mainstay of her approach.

Soon after von Alten met Richard Oelze in 1954, the two artists struck up a lasting friendship. Oelze recognized an affinity for fantastical abstraction in her work and encouraged her to strive toward "the inner vision of things."[1] This emphasis on interiority is the legacy of German Romanticism as well as a major motivation of the Surrealists, among whom Oelze counted himself. With Oelze's supportive presence and insights shared from his experience with Surrealism in Paris (1933-36), von Alten applied to her art her aptitude for freeing the imagination and as a result, she flourished.

Together with Oelze, von Alten regularly attended exhibitions of avant-garde art on view in postwar Germany. Notable are exhibitions of Pablo Picasso; Wassily Kandinsky; Paul Klee; Max Ernst; the abstract works of the *Informel* artists such as German émigrés Hans

Hartung and Wols; Jean Dubuffet's *Art Brut* emulating the naïve art of amateurs, children, and the insane; the new performance art, called *Happenings*; and conceptual art of *Fluxus*.[2] From its inception in 1955 von Alten and Oelze made *documenta*, the contemporary art exhibition in Kassel, a regular stop in their exhibition itinerary. Steeped in avant-garde and contemporary art and buoyed by Oelze's encouragement, von Alten's art thrived during the 1960s. She participated in group exhibitions in Hannover, Munich, Hagen, Hameln, and Nürnberg and her work was purchased by the city of Stade, the city of Hannover, and the Wolfsburg Museum.[3]

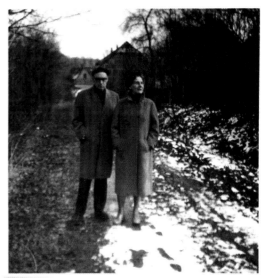

Ellida Schargo von Alten and Richard Oelze walking in Posteholz, ca. 1967. Photograph Courtesy of Jessica G. Davis

Most of the drawings and pastels in this exhibition were made at the apex of von Alten's career as a visual artist. The gestural traces of her pastel method are related to Surrealist automatism, a technique for circumventing the conscious control of the rational mind in order to access the deeper recesses of the subconscious and unconscious. The Surrealist Max Ernst used rubbing techniques of *frottage* and scraping away of paint known as *grattage* to reduce rational control in composing and executing pictures. Von Alten adapted this Surrealist effect to the pastel medium by layering gestural strokes rather than rubbing and scraping to build up the illusion of texture and deep surfaces. Her application of this technique to subject matter that oscillates between barely recognizable organic form and pure abstraction parallels developments in contemporary art of the period. Artists of European *Informel* and American Abstract Expressionism also borrowed from Surrealist *automatism* to draw out the inner wellspring of the psyche and release the unconscious. Von Alten's gestural pastels differ in the intimacy of small-scale works that feature humor, rather than the existential brooding common in her contemporaries'

work—including Oelze's. Her whimsical compositions with their light mood and fluid passages of textured layers recall the fantastical adventures narrated in her writings.

In 1962 von Alten arranged for Oelze to reside with her at Rittergut Posteholz, the von Alten family estate where she had spent so many childhood summers. She wanted the idyllic quietude of this rural retreat to sustain Oelze in the prime of his artistic career, as he increasingly felt harassed in Worpswede. Gradually he isolated himself, and depended wholly on von Alten for his existence. In 1970 her role as nurturing supporter and studio manager was transformed into full-time caregiver when Oelze's condition worsened and he ceased painting and drawing. For the next decade she devoted herself fully to his care and, like many women caregivers, set aside her own artistic career. Her production of drawings and pastels diminished dramatically compared to her prolific output in the 1950s and 60s. Her last major works were produced ca. 1975.[4] Meanwhile von Alten's rheumatoid arthritis, which she had stoically endured since early adulthood, became increasingly painful. As a result, once her role as caregiver came to an end with Oelze's death in 1980, she was physically no longer able produce new drawings and pastels, although she did create a small number of works in collage for family and friends.[5] She remained a fixture in the artistic community and participated in organizing exhibitions of Oelze's art including a major retrospective in 1988/89. Toward the end of her life von Alten was honored with two solo exhibitions of her own work: in 1991 at the Kunstverein Hameln and in 1994 at the Galerie Cohrs-Zirus in Worpswede. She died in 1996.

1 "Biographie" in *Ellida Schargo von Alten: Zeichnungen und Gemälde* (Worpswede: Galerie Cohrs-Zirus, 1994), 6.

2 "Biographie," 6-7.

3 "Biographie," 7. See also archivalia in the Schargorodsky collection; these papers were carefully preserved by the artist and document her correspondence pertaining to her participation in exhibitions.

4 See archivalia in the Schargorodsky collection.

5 Personal communication with Till Schargorodsky and Friederun Hampel, July 2012. See also archivalia in the Schargorodsky collection.

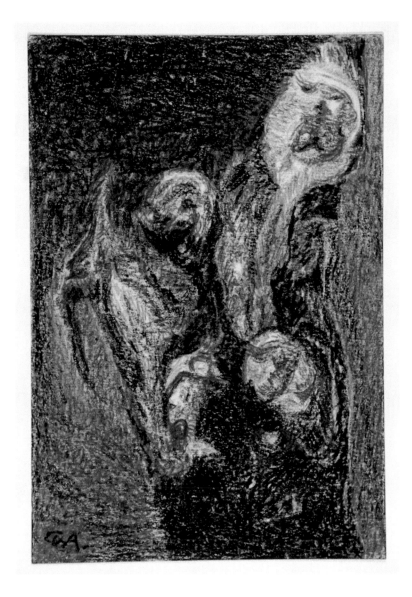

Drei heilige Könige, 1962
Three Wise Men
Conté crayon and graphite on paper
14.5 x 10.5 cm (5 ¾ x 4 1/8 in),
signed lower left
On loan from Jessica G. Davis, Erik V. Davis,
Emily K. Abraham and Marc B. Davis

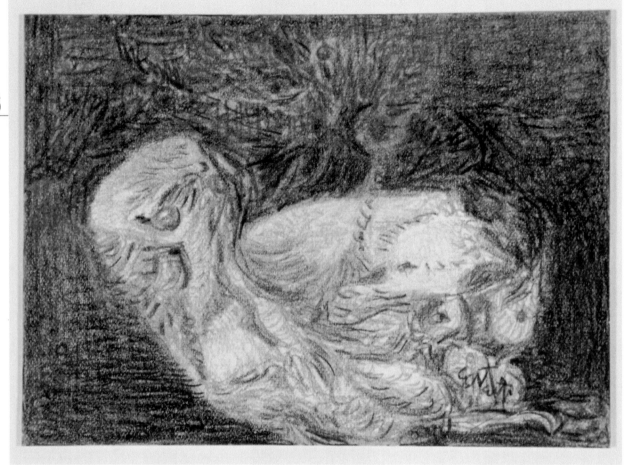

Oster Lamm, 1975
Easter Lamb
Graphite on paper
12.5 x 17.5 cm (4 7/8 x 6 7/8 in), signed
twice at lower right
On loan from Jessica G. Davis, Erik V. Davis,
Emily K. Abraham and Marc B. Davis

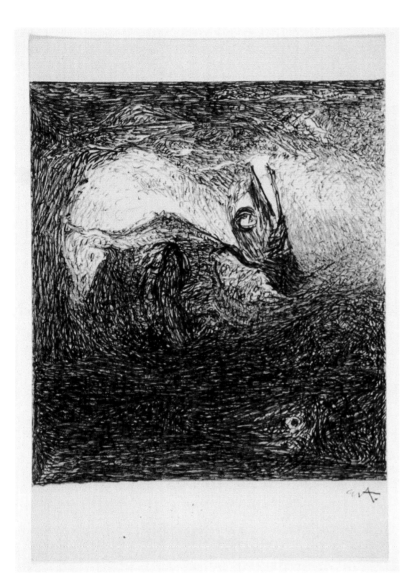

On the reverse of this drawing von Alten has inscribed the words "... *Das Mondschaf spricht zu sich im Traum: 'Ich bin des Weltalls dunkle [sic] Raum.' Das Mondschaf. ...* (Morgenstern)" This is the 4th stanza of Christian Morgenstern's *Galgendichtung* or "gallows poem" of the same name (1st ed. Berlin, 1932). The whole poem reads: "*Das Mondschaf steht auf weiter Flur. / Es harrt und harrt der großen Schur. / Das Mondschaf. // Das Mondschaf rupft sich einen Halm / und geht dann heim auf seine Alm. / Das Mondschaf. // Das Mondschaf spricht zu sich im Traum: / 'Ich bin des Weltalls dunkler Raum.' / Das Mondschaf. // Das Mondschaf liegt am Morgen tot. / Sein Leib ist weiß, die Sonn' ist rot. / Das Mondschaf.*"

The Moon-Sheep stands in the field [implied: all alone in the world]. It awaits the great shearing. The Moon-Sheep plucks a stalk of grass and then goes home to his alpine pasture [double entendre: *rupfen* also means to fleece, as in taking unfair advantage]. The Moon-Sheep says to itself in a dream: "I am the dark expanse of the cosmos." In the morning the Moon-Sheep lies dead. His body is white, the sun is red.

The title of the poem may be a pun on the colloquialism *das Mondkalb*, which means dim-wit or idiot.

Das Mondschaf, undated
The Moon-Sheep
Pen on paper
14.5 x 10.5 cm (5 ¾ x 4 1/8 in),
signed lower right
On loan from Jessica G. Davis, Erik V. Davis, Emily K. Abraham and Marc B. Davis

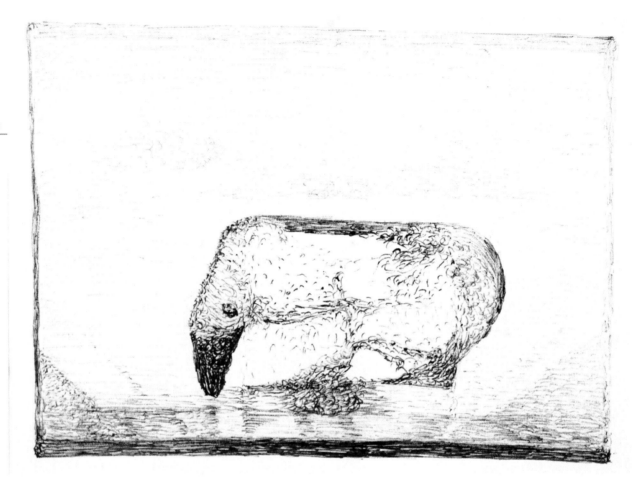

Mein Schaf, undated
My Sheep
Pen on paper
11.5 x 16 cm (4 ½ x 6 3/8 in) on sheet of size
21 x 29.5 cm (8/3/8 x 11 5/8 in), unsigned
On loan from Jessica G. Davis, Erik V. Davis,
Emily K. Abraham and Marc B. Davis

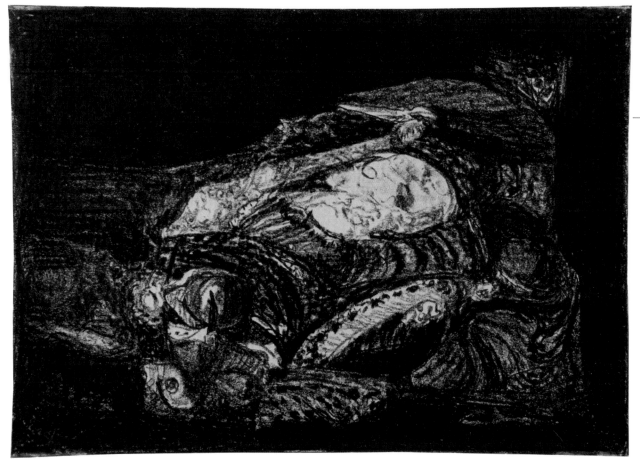

Knieendes Tier, ca. 1949
Kneeling Animal
Conté crayon on paper
30 x 21 cm (11 ¾ x 8 3/8 in), signed lower left
On loan from Jessica G. Davis, Erik V. Davis,
Emily K. Abraham and Marc B. Davis

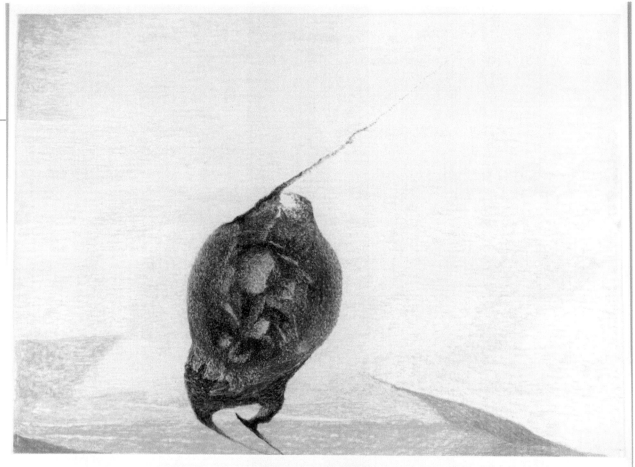

Der Flohmaster, 1964
The Fattened Flea
Pastel on paper
43 x 61 cm (16 7/8 x 24 in), unsigned
On loan from Jessica G. Davis, Erik V. Davis,
Emily K. Abraham and Marc B. Davis

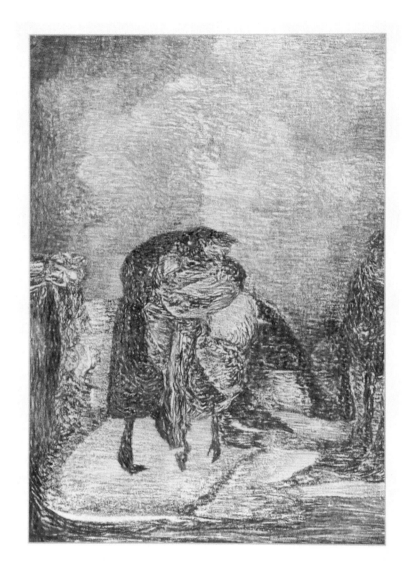

Erinnerung an Stevenson, 1949
Memory of Stevenson
Pastel on paper
43.5 x 32 cm (17 1/8 x 12 5/8 in),
unsigned
On loan from Jessica C. Davis, Erik V. Davis,
Emily K. Abraham and Marc B. Davis

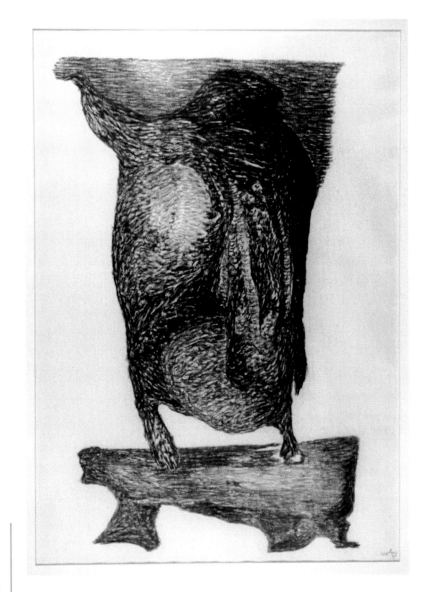

Untitled, undated
Charcoal on paper
55.9 x 72.4 cm (22 x 28 ½ in),
signed lower right
On loan from Jessica G. Davis

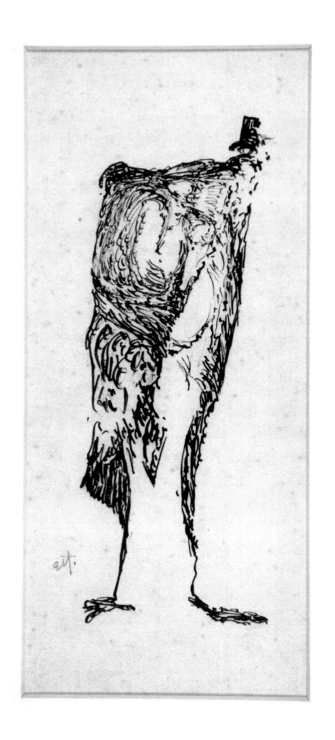

Untitled, undated
Pen and ink on paper
20.3 x 30.5 cm (8 x 12 in), signed lower left
On loan from Jessica G. Davis

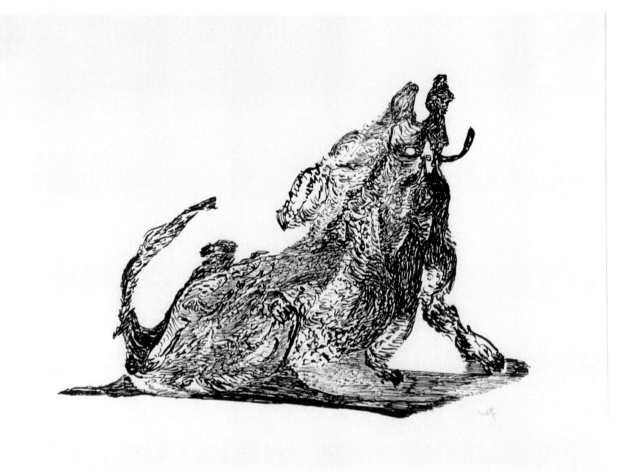

Der Bote, 1959
The Messenger
Pen and ink on paper
31.8 x 40.6 cm (12 ½ x 16 in), signed lower right
On loan from Jessica G. Davis

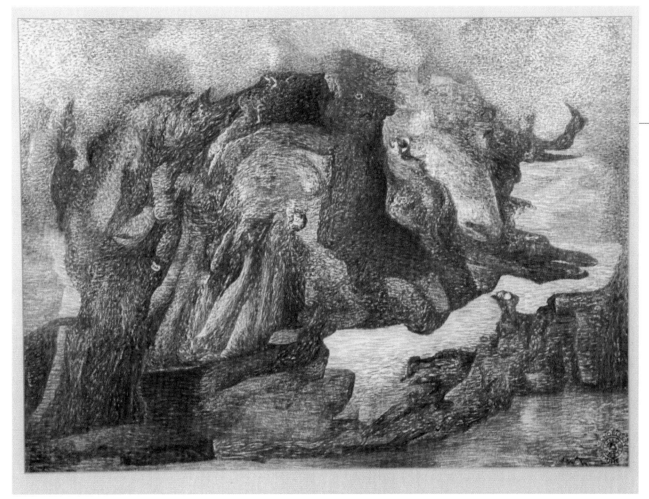

Stier, 1965
Bull
Charcoal on paper
76.2 x 58.4 cm (30 x 23 in), signed lower right
On loan from Jessica G. Davis

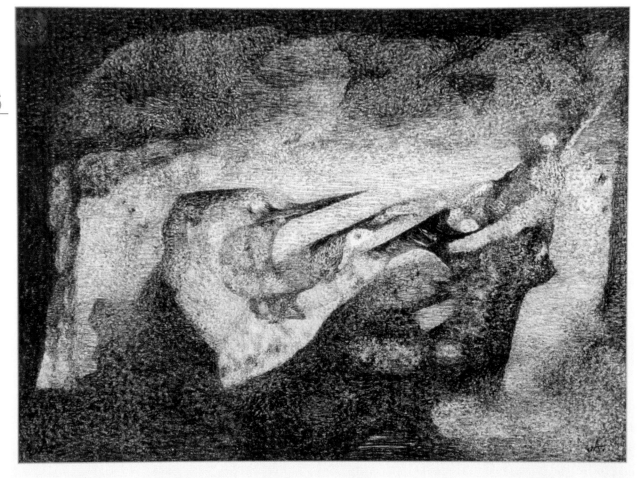

Umschau, undated
Survey
Pastel on paper
73.7 x 57.2 cm (29 x 22 ½ in), signed twice:
lower right & lower left
On loan from Jessica G. Davis

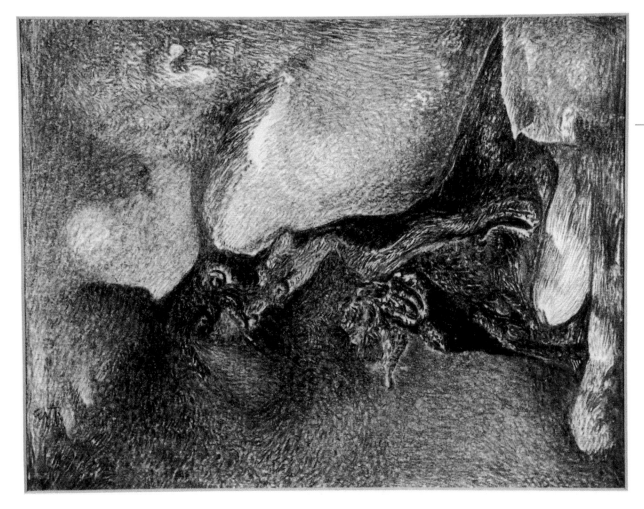

Untitled, undated
Charcoal on paper
43.2 x 35.6 cm (17 x 14 in), signed lower left
On loan from Jessica G. Davis

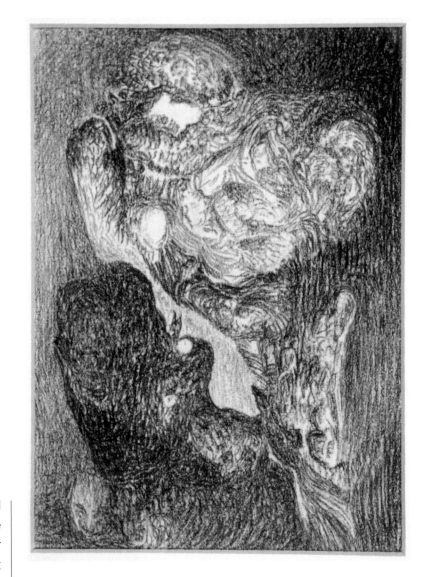

Flaschengeist, undated
Genie
Charcoal on paper
25.4 x 27.9 cm (10 x 11 in), signed lower left
On loan from Jessica G. Davis

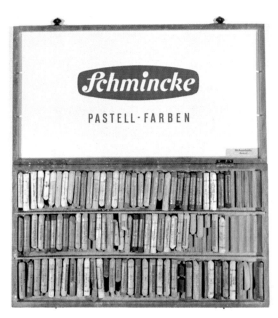

Ellida Schargo von Alten's pastel box
H. Schminke & Company Pastel Box
Courtesy of Jessica G. Davis

Ellida Schargo von Alten's medium of choice was pastel. She used the chalky sticks as a drawing utensil to make linear marks as well as shading and blended strokes. In some compositions she also treated pastel as a painting medium by layering it with wet techniques such as *gouache*, an opaque water-based medium. After applying strokes of color to the paper support, she would use a moistened brush to create a color wash; this can be seen for example in *Farbstudie* (Pointilismus), ca. 1965 (pastel, 65 x 50 cm), which shows evidence of both pastel and gouache. In other compositions, scumbled and stippled strokes are layered together with broken color and blended strokes and then overlaid with linear skeins in ink, charcoal, or pencil, for example in *Aphorismen* (Aphorisms), 1967 (pastel, charcoal and pen, 45 x 62.5 cm).

These complex approaches to pastel indicate von Alten's experimental treatment of the medium. The effect of combining various pastel techniques creates an illusion of advancing and receding that takes place within a narrow slice of space, but nevertheless allows optical perception to challenge spatial stability. She even dissolved fixed orientation, occasionally signing a work twice, as in *Traum* (Dream), undated (pastel on paper, 70 x 50 cm), to indicate multiple viewing positions. Such spatial effects can be seen in the "all over" paintings of American Abstract Expressionist painters, whose

work she could have known from the international *documenta* exhibitions of 1955 and 1960.

The pastel medium itself has a long history, partly tied to class and gender. Manufactured pastels were first used for preparatory drawings by Renaissance artists, such as Leonardo da Vinci.[1] At the turn of the 18th century, pastel was elevated beyond a sketching tool and in the 1720s was popularized among the aristocracy in France as a fine art medium by the Italian Rosalba Carriera.[2] The soft contour and subtle modeling possible with pastel appealed to the new Rococo taste for an elegant alternative to the hard-edge classical manner of French Baroque. Like Carriera before her, von Alten was an innovator in pastel. Her initial exposure to techniques of drawing stems from conventions in aristocratic education traceable to the gender-biased principles of Enlightenment philosopher Jean-Jacques Rousseau.[3] Pastel retained Rococo's association with the aristocracy as it became a staple in the homes of upper-class families, who expected their daughters to receive training in the arts of drawing, needlework, and music. A young woman who could demonstrate excellence at pastel, watercolor, and portrait rendering – in addition to embroidery, tatting, singing, and piano—was regarded as a proper exemplar of her class.[4] And reading literature was a given in privileged society, regardless of gender. These expectations persisted into the 20th century; von Alten's mother Emmy von Poten excelled in nature drawings with exacting verisimilitude.

Ellida Schargo von Alten's pastel box
H. Schminke & Company Pastel Box
Courtesy of Jessica G. Davis

As a multi-talented artist, von Alten harnessed a medium associated with the refinement of elite women and imbued it with the force of avant-garde art. Nineteenth-century artists such as Edgar Degas and Mary Cassatt had begun experimenting with pastel techniques, departing from the traditional use of dry application by adding water to create a color wash that can be worked with a brush. Odilon Redon exploited the saturated quality of pastel to produce jewel-like

compositions that rival the intensity of his oil paintings.[5] Later, 20th-century modernists such as Pablo Picasso and the Expressionist artists of *Brücke* (Bridge) dabbled in pastel as a drawing tool. But von Alten stands out for her innovation in combining pastel methods in experimental ways to pioneer the application of pastel as a medium to the pursuit of abstraction. The abstract artists working just before and after the Great War painted primarily in oil on canvas, and von Alten's post-WWII contemporaries often treated oil paint as a sculptural medium by building up impasto surfaces. Von Alten, however, exploited the two-dimensional characteristics of pastel on paper to imply three-dimensional texture. By manipulating the pastel sticks and allowing the tooth of the rough-grain paper to participate in a composition's appearance, as with *frottage,* she relied upon the viewer to conceptualize deep space and advancing masses. She refused definitive interpretation of her imagery and preferred that viewers look into the work and derive their own meaning from it.[6] By bringing pastel and abstraction together, Ellida Schargo von Alten left her unique mark on modern art.

1 Geneviève Monnier, "Pastel," *Oxford-Grove Art Online*, 9 November 2009 (accessed 13 January 2012).

2 Whitney Chadwick, *Women, Art and Society*, 4th ed. (London: Thames and Hudson, 2007), 141-2.

3 See Jean-Jacques Rousseau, *Émile, or, On Education* (1762). Trans. and ed. Christopher Kelly and Allan Bloom (Hanover, NH: Dartmouth College Press, 2010).

4 See for example the novels of Jane Austen, such as *Sense and Sensibility* (1811), *Pride and Prejudice* (1813), *Emma* (1815/16), and *Persuasion* (1817).

5 Thanks to Christiane Hertel for pointing me to Redon.

6 Personal communication with Julia Bachmann, July 2012; see also archivalia in the Schargorodsky collection.

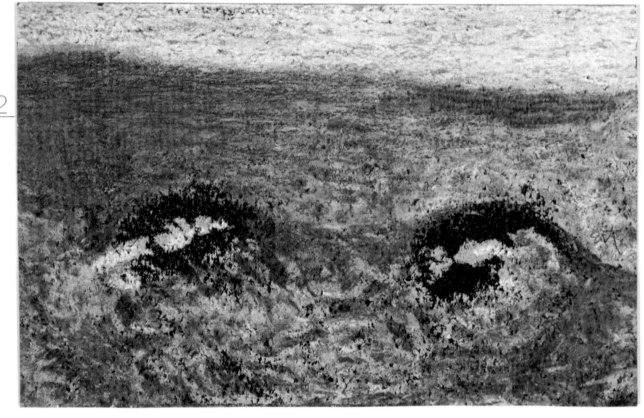

Untitled, undated
Pastel on black paper
15.9 x 10 cm (6 1/4 x 3 7/8 in), signed at right
On loan from Jessica G. Davis

In this example von Alten heightened the visibility of the Schoeller Turm watermark on the paper support with its symbol of a tall-masted ship. She was named after "The Ellida," the tall ship her grandfather captained, and thus the emphasized watermark symbol serves as a whimsical visual signature.

The title of the work, Felsenauge, is also an imaginative linguistic concoction in the spirit of Surrealist word games. It means Rock Eye or Eye of the Rock (as in geological bedrock). This could be a pun on the word die Felsnase (lit. rock nose) which means ledge.

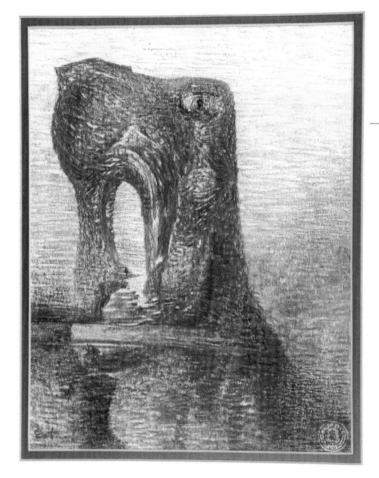

Felsenauge, undated
Rock Eye or Eye of the Rock
Charcoal and pastel on paper
35.6 x 43.2 cm (14 x 17 in), signed lower left
On loan from Jessica G. Davis

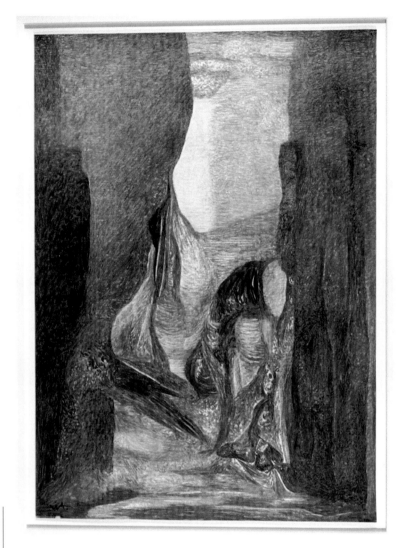

Netze, 1953
Nets (or Moisten)
Charcoal on paper
62.5 x 45 cm (24 5/8 x 17 ¾ in),
signed lower left
On loan from Jessica G. Davis, Erik V. Davis,
Emily K. Abraham and Marc B. Davis

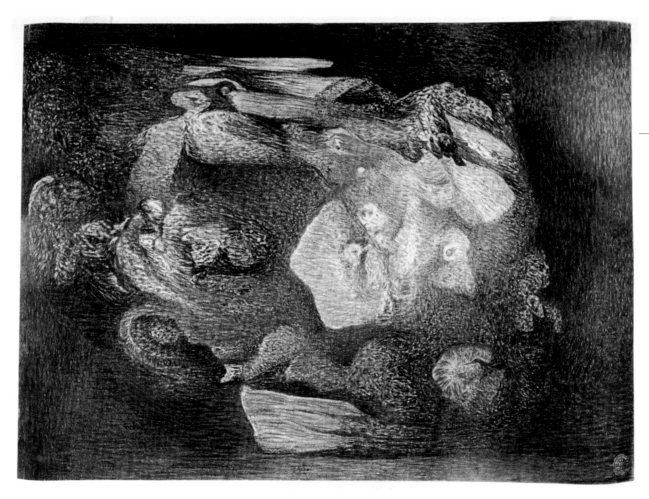

In this example von Alten heightened the visibility of the Schoeller Turm watermark on the paper support with its symbol of a tall-masted ship. She was named after "The Ellida," the tall ship her grandfather captained, and thus the emphasized watermark symbol serves as a whimsical visual signature.

Vogelinsel, 1967
Bird Island
Charcoal on paper
45 x 63 cm (17 ¾ x 24 7/8 in), signed bottom center
On loan from Jessica G. Davis, Erik V. Davis,
Emily K. Abraham and Marc B. Davis

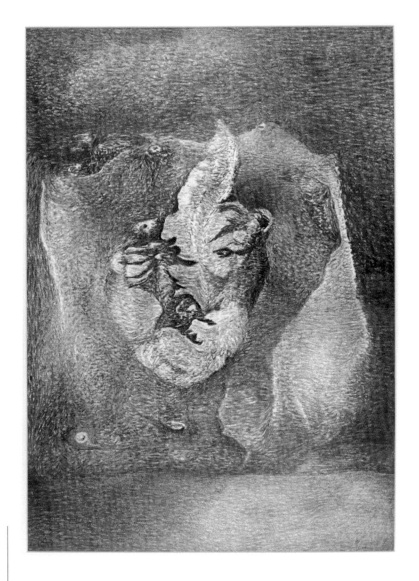

Untitled, undated
Charcoal on paper
61 x 44 cm (24 x 17 3/8 in),
signed lower left
On loan from Jessica G. Davis, Erik V. Davis,
Emily K. Abraham and Marc B. Davis

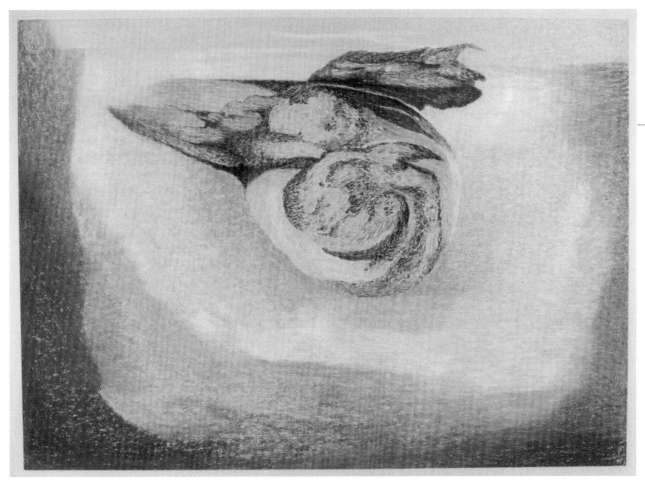

Günstling der Natur, ca. 1960
Favorite of Nature
Pastel on paper
66 x 83.8 cm (26 x 33 in), signed twice at
lower right
On loan from Jessica G. Davis

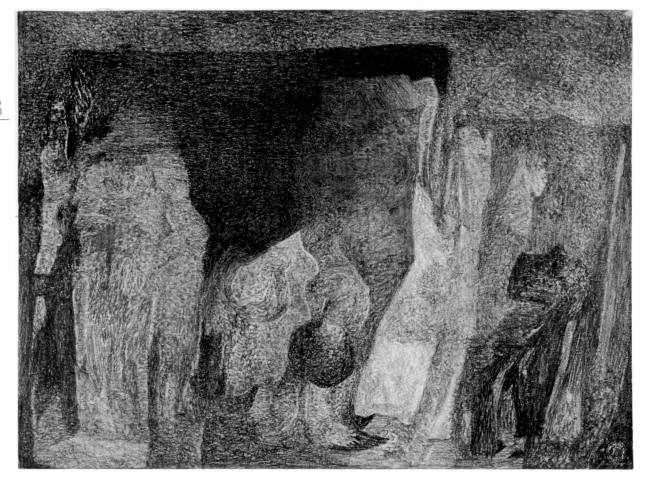

Aphorismen, 1967
Aphorisms
Pastel, charcoal, and pen on paper
45 x 62.5 cm (17 ¾ x 24 5/8 in), signed lower left
On loan from Jessica G. Davis, Erik V. Davis,
Emily K. Abraham and Marc B. Davis

In this example von Alten heightened the visibility of the Schoeller Turm watermark on the paper support with its symbol of a tall-masted ship. She was named after "The Ellida," the tall ship her grandfather captained, and thus the emphasized watermark symbol serves as a whimsical visual signature.

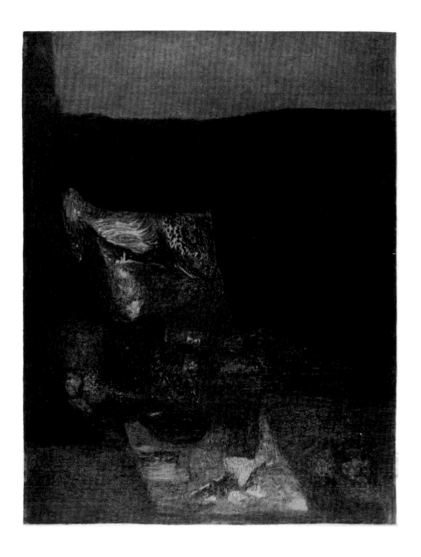

Zufällige Erscheinung, 1957
Coincidental Appearance
Pastel and charcoal on paper
62.5 x 48 cm (24 5/8 x 18 7/8 in), signed
lower left
On loan from Jessica G. Davis, Erik V.
Davis, Emily K. Abraham and Marc B.
Davis

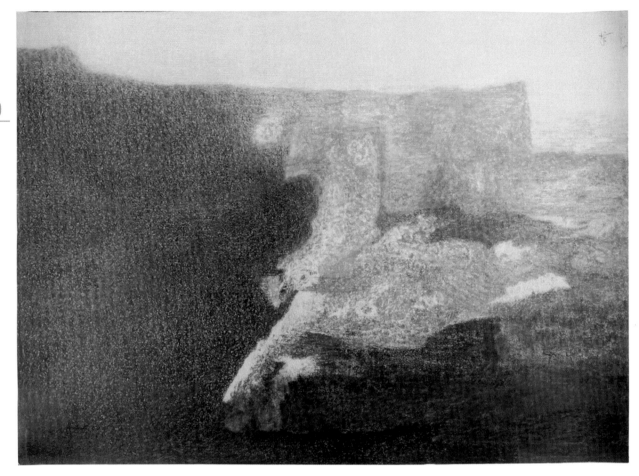

Traum, undated
Dream
Pastel on cardstock
70 x 50 cm (27 5/8 x 19 ¾ in), signed twice
at lower left and upper right
On loan from Jessica G. Davis, Erik V. Davis,
Emily K. Abraham and Marc B. Davis

Exhibitions and the catalogues that accompany them are the products of collaborative effort. I thank Linny Frickman for keen curatorial and editorial consultation and for her friendship; Keith Jentzsch for installing and making the art works pop on the gallery walls; Suzanne Hale for shepherding the works through logistics; Silvia Minguzzi for her deft design work on the catalogue; and Eli Hall and Jennifer Clary for publicity design. Gary Huibregtse deserves special credit for his patient assistance with photographic documentation of the exhibition and individual art works.

The exhibition was sponsored by the Colorado State University Art Museum and the Department of Art. Catalogue production was generously funded by a Lilla B. Morgan grant with assistance from the University Art Museum; catalogue design was sponsored by Gary Voss of the Art Department. My ongoing research on Ellida Schargo von Alten has been facilitated by a Faculty Development Fund award from CSU.

I would like express my deep appreciation to Till and Hilde Schargorodsky in Germany, who opened their home and hearts to me as they led me on what has become a continuing adventure of discovery and fascination. Their collection of Ellida's art, papers, and memorabilia and their stories of her life and her character have been indispensible for this project while providing the germ for my ongoing scholarship on Ellida.

Jess Davis deserves special credit for sparking the idea for this exhibition by sharing with me her grandmother's visual and written work. Emily Abraham opened her personal collection of Ellida's works as well as her grandmother's collection of dolls and curios for my study. Erik Davis and Marc Davis kindly shared their grandmother's art works for extended study. Nina Schargorodsky, Julia Bachmann, Svea Schargorodsky, and Jonas Schargorodsky filled in my understanding of Ellida's life and her art and shared their collections with me.

Special thanks to Frau Friederun Hampel for illuminating aspects of Ellida's young life and Herr Wilfried Cohrs and Dr. Daniel Clair Davis for sharing their perceptions of Ellida's art and life in her mature years. Frau Beate Arnold at the Barkenhoff-Stiftung, Worpswede and Frau Katharina Groth at the Oelze-Archiv, Bremen facilitated archival research.

Thanks also to Boris Brockstedt who allowed me to study his gallery's collection in Hamburg and Berlin of works by Richard Oelze, Ellida's life partner. Research facilitated by these individuals informs my monograph on Ellida, now in progress.

Permission for reproduction of art works has been generously granted by:
 Till and Hilde Schargorodsky, for the estate of Ellida Schargo von Alten
 Jessica G. Davis, for art works in her personal collection
 Jessica G. Davis, Emily K. Abraham, Erik V. Davis, and Marc B. Davis for art works held jointly